Love in art and verse

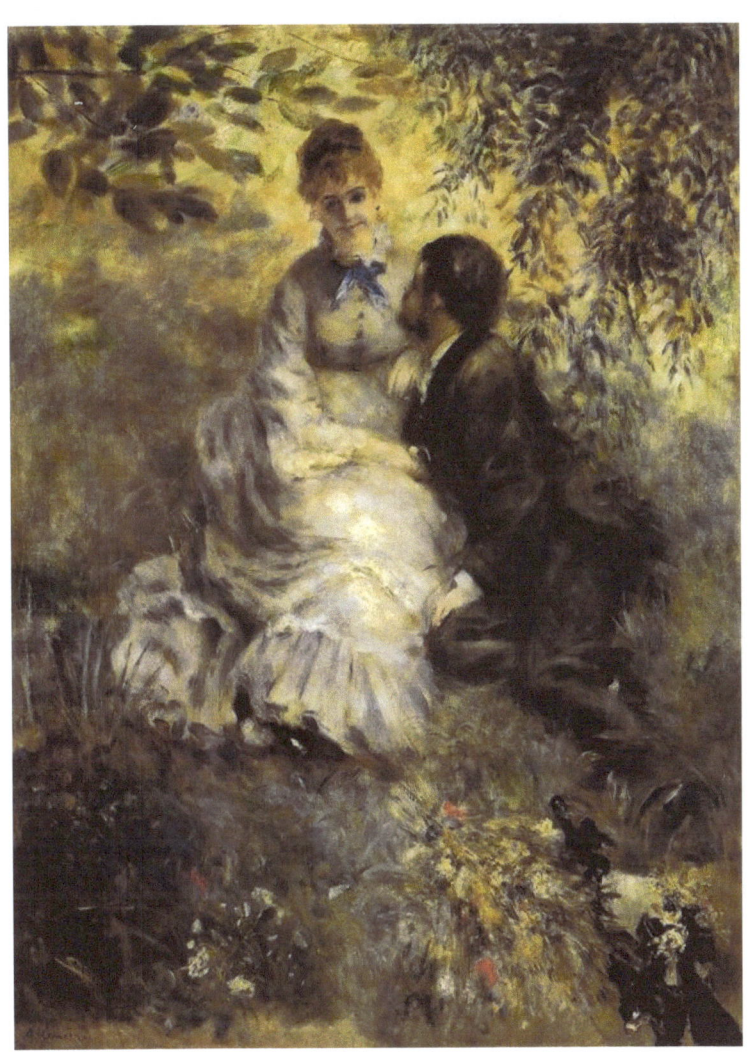

Edited by Lacey Belinda Smith

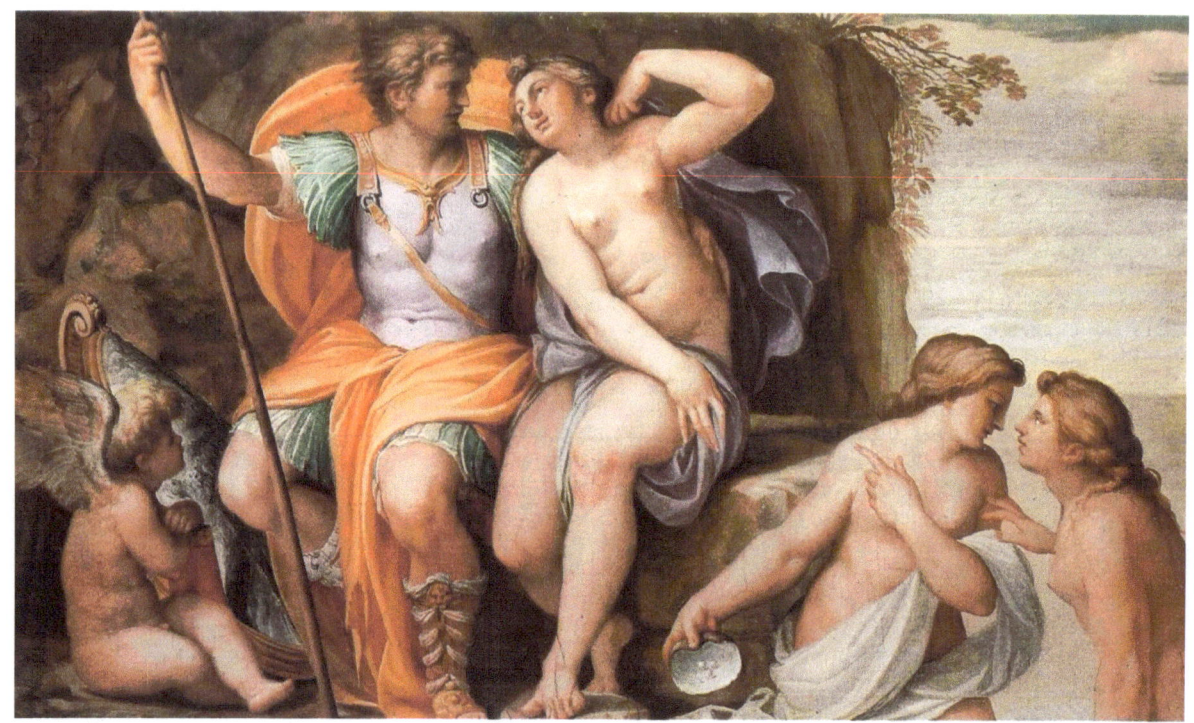

Venus and Mars-- Agostino Carracci—1600-- Baroque-- mythological painting

I loved thee Atthis...
'Love shook my heart'

Love shook my heart,
Like the wind on the mountain

Troubling the oak-trees.

 Algernon Charles Swinburne

Daphnis and Chloe-- Pierre-Paul Prud'hon----1802--Neoclassicism--mythological painting

PORPHYRIA'S LOVER

The rain set early in to-night,
 The sullen wind was soon awake,
It tore the elm-tops down for spite,
 And did its worst to vex the lake:
 I listened with heart fit to break.
When glided in Porphyria; straight
 She shut the cold out and the storm,
And kneeled and made the cheerless grate
 Blaze up, and all the cottage warm;
 Which done, she rose, and from her form 10
Withdrew the dripping cloak and shawl,
 And laid her soiled gloves by, untied
Her hat and let the damp hair fall,
 And, last, she sat down by my side
 And called me. When no voice replied,
She put my arm about her waist,
 And made her smooth white shoulder bare,
And all her yellow hair displaced,
 And, stooping, made my cheek lie there,
 And spread, o'er all, her yellow hair, 20
Murmuring how she loved me—she
 Too weak, for all her heart's endeavour,
To set its struggling passion free
 From pride, and vainer ties dissever,
 And give herself to me for ever.
But passion sometimes would prevail,
 Nor could to-night's gay feast restrain
A sudden thought of one so pale
 For love of her, and all in vain:
 So, she was come through wind and rain. 30

Be sure I looked up at her eyes
 Happy and proud; at last I knew
Porphyria worshipped me; surprise
 Made my heart swell, and still it grew
 While I debated what to do.
That moment she was mine, mine, fair,
 Perfectly pure and good: I found
A thing to do, and all her hair
 In one long yellow string I wound
 Three times her little throat around, 40
And strangled her. No pain felt she;
 I am quite sure she felt no pain.
As a shut bud that holds a bee,
 I warily oped her lids: again
 Laughed the blue eyes without a stain.
And I untightened next the tress
 About her neck; her cheek once more
Blushed bright beneath my burning kiss:
 I propped her head up as before,
 Only, this time my shoulder bore 50
Her head, which droops upon it still:
 The smiling rosy little head,
So glad it has its utmost will,
 That all it scorned at once is fled,
And I, its love, am gained instead!
Porphyria's love: she guessed not how
 Her darling one wish would be heard.
And thus we sit together now,
 And all night long we have not stirred,
 And yet God has not said a word! 60

NOTES:
"Porphyria's Lover" relates how, by strangling Porphyria

with her own yellow hair, the lover seized and preserved
the moment of perfect love when, pure and good, Porphyria
left the world she could not forego for his sake,
and came to him, for once conquered by her love. A
latent misgiving as to his action is intimated in the closing
line of the poem.

 Remarking upon the fact that Browning removed the
original title, "Madhouse Cells," which headed this poem,
and "Johannes Agricola in Meditation," Mrs. Orr says:
"Such a crime might be committed in a momentary
aberration, or even intense excitement of feeling. It is
characterized here by a matter-of-fact simplicity, which is
its sign of madness. The distinction, however, is subtle;
and we can easily guess why this and its companion poem
did not retain their title. A madness which is fit for
dramatic treatment is not sufficiently removed from
sanity."

By Robert Browning

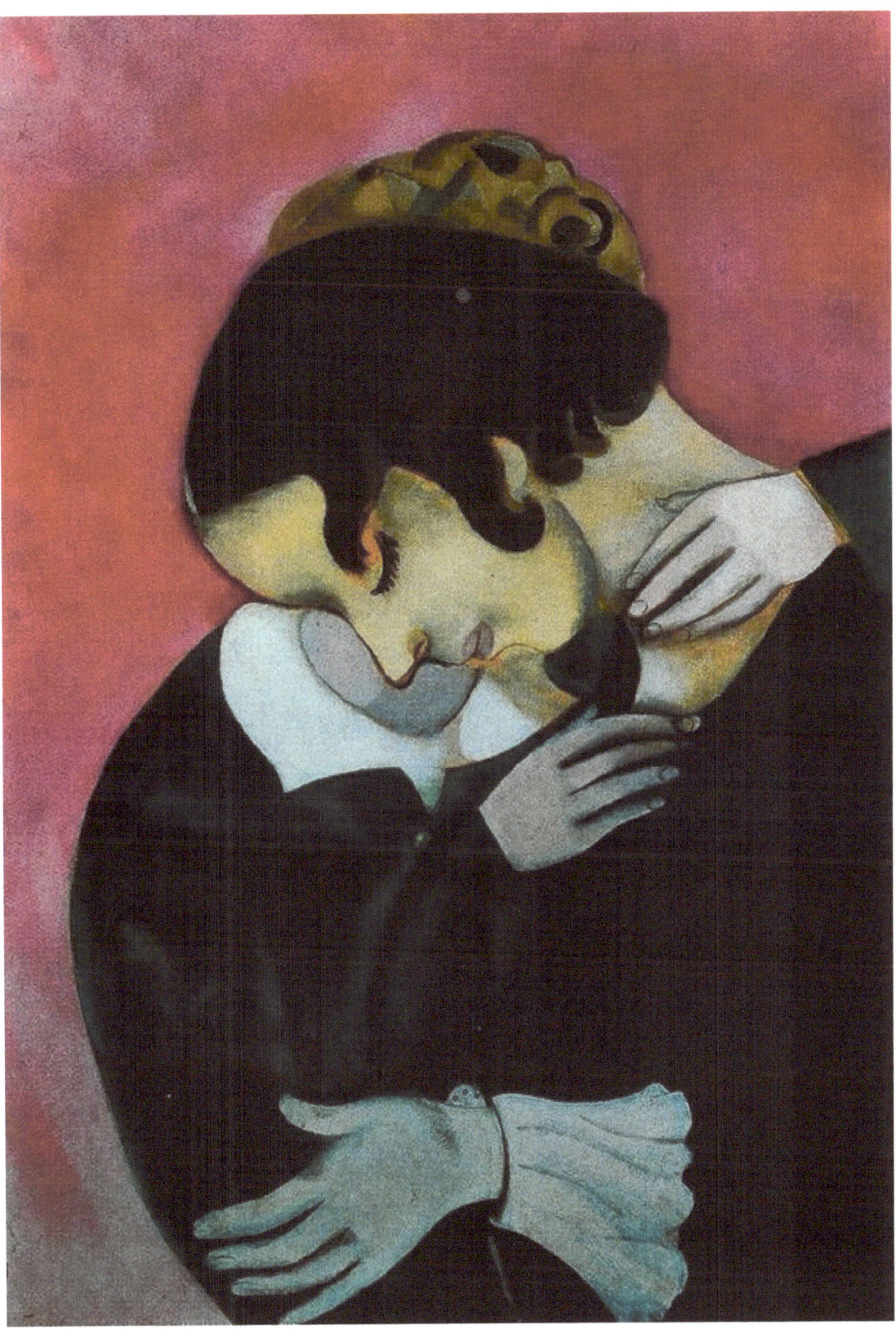

Lovers in pink--Marc Chagall—1916--Cubism

On Monsieur's Departure
BY QUEEN ELIZABETH I

I grieve and dare not show my discontent,

I love and yet am forced to seem to hate,

I do, yet dare not say I ever meant,

I seem stark mute but inwardly do prate.

 I am and not, I freeze and yet am burned,

 Since from myself another self I turned.

My care is like my shadow in the sun,

Follows me flying, flies when I pursue it,

Stands and lies by me, doth what I have done.

His too familiar care doth make me rue it.

 No means I find to rid him from my breast,

 Till by the end of things it be supprest.

Some gentler passion slide into my mind,

For I am soft and made of melting snow;

Or be more cruel, love, and so be kind.

Let me or float or sink, be high or low.

Or let me live with some more sweet content,

Or die and so forget what love ere meant.

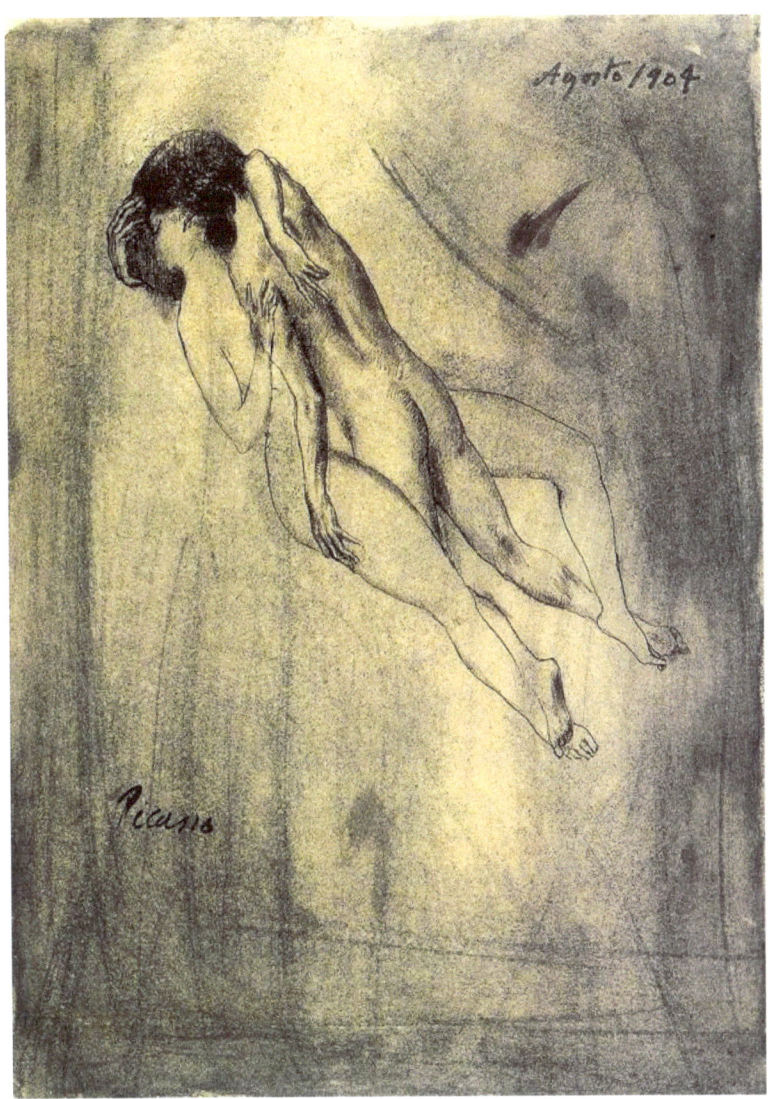

Lovers--Pablo Picasso—1904--Expressionism

LOVE AT SEA

We are in love's land to-day;
Where shall we go?
Love, shall we start or stay,
Or sail or row?
There's many a wind and way,
And never a May but May;
We are in love's hand to-day;
Where shall we go?

Our landwind is the breath
Of sorrows kissed to death
And joys that were;
Our ballast is a rose;
Our way lies where God knows
And love knows where.
We are in love's hand to-day—

Our seamen are fledged Loves,
Our masts are bills of doves,
Our decks fine gold;
Our ropes are dead maids' hair,
Our stores are love-shafts fair
And manifold.
We are in love's land to-day—

Where shall we land you, sweet?
On fields of strange men's feet,
Or fields near home?
Or where the fire-flowers blow,
Or where the flowers of snow
Or flowers of foam?
We are in love's hand to-day—

Land me, she says, where love
Shows but one shaft, one dove,
One heart, one hand.
—A shore like that, my dear,
Lies where no man will steer,
No maiden land.

Imitated from Théophile Gautier.

Algernon Charles Swinburne

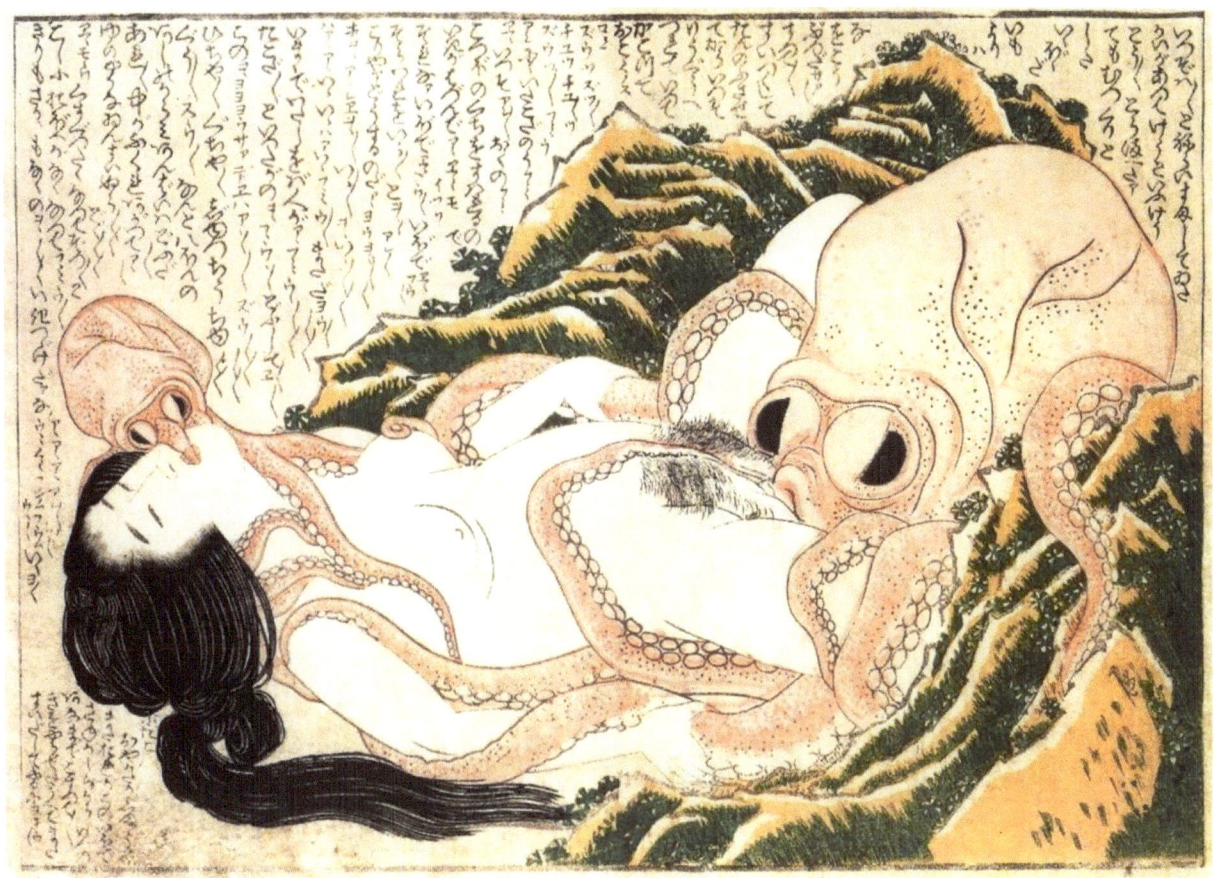

The Dream of the Fisherman's Wife-- Katsushika Hokusai—1814-- Ukiyo-e

THE YEAR OF LOVE

There were four loves that one by one,Following the seasons and the sun,Passed over without tears, and fellAway without farewell.

The first was made of gold and tears,The next of aspen-leaves and fears,The third of rose-boughs and rose-roots,The last love of strange fruits.

These were the four loves faded. HoldSome minutes fast the time of goldWhen our lips each way clung and cloveTo a face full of love.

The tears inside our eyelids met,Wrung forth with kissing, and wept wetThe faces cleaving each to eachWhere the blood served for speech.

The second, with low patient browsBound under aspen-coloured boughsAnd eyes made strong and grave with sleepAnd yet too weak to weep—

The third, with eager mouth at easeFed from late autumn honey, leesOf scarce gold left in latter cellsWith scattered flower-smells—

Hair sprinkled over with spoilt sweetOf ruined roses, wrists and feetSlight-swathed, as grassy-girdled sheavesHold in stray poppy-leaves—

The fourth, with lips whereon has bledSome great pale fruit's slow colour, shedFrom the rank bitter husk whence dripsFaint blood between her lips—

Made of the heat of whole great JunesBurning the blue dark round their moons(Each like a mown red marigold)So hard the flame keeps hold—

These are burnt thoroughly away.Only the first holds out a dayBeyond these latter loves that wereMade of mere heat and air.

And now the time is winterlyThe first love fades too: none will see,When April warms the world anew,The place wherein love grew.

Algernon Charles Swinburne

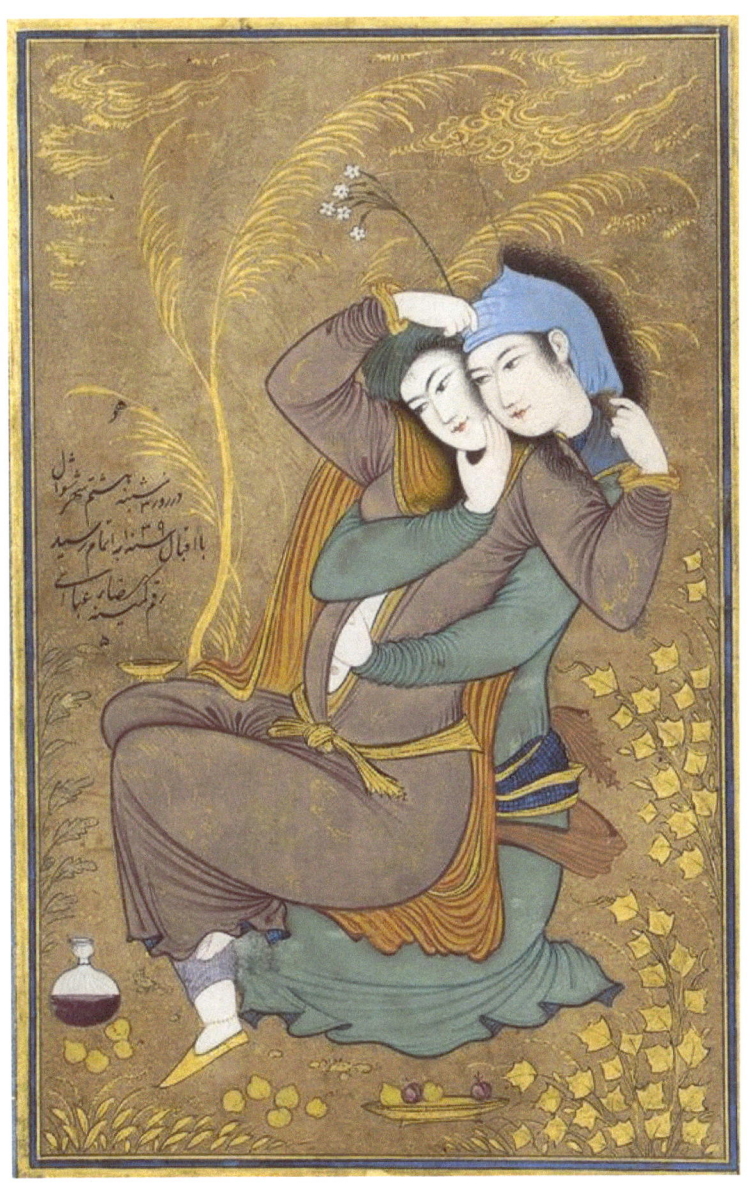

Two Lovers-- Reza Abbasi-- 1630

SAPPHICS

All the night sleep came not upon my eyelids,Shed not dew, nor shook nor unclosed a feather,Yet with lips shut close and with eyes of ironStood and beheld me.

Then to me so lying awake a visionCame without sleep over the seas and touched me,Softly touched mine eyelids and lips; and I too,Full of the vision,

Saw the white implacable Aphrodite,Saw the hair unbound and the feet unsandalledShine as fire of sunset on western waters;Saw the reluctant

Feet, the straining plumes of the doves that drew her,Looking always, looking with necks reverted,Back to Lesbos, back to the hills whereunderShone Mitylene;

Heard the flying feet of the Loves behind herMake a sudden thunder upon the waters,As the thunder flung from the strong unclosingWings of a great wind.

So the goddess fled from her place, with awfulSound of feet and thunder of wings around her;While behind a clamour of singing womenSevered the twilight.

Ah the singing, ah the delight, the passion!All the Loves wept, listening; sick with anguish,Stood the crowned nine Muses about Apollo;Fear was upon them,

While the tenth sang wonderful things they knew not.Ah the tenth, the Lesbian! the nine were silent,None endured the sound of her song for weeping;Laurel by laurel,

Faded all their crowns; but about her forehead,Round her woven tresses and ashen templesWhite as dead snow, paler than grass in summer,Ravaged with kisses,

Shone a light of fire as a crown for ever. Yea, almost the implacable Aphrodite
Paused, and almost wept; such a song was that song. Yea, by her name too

Called her, saying, "Turn to me, O my Sappho;" Yet she turned her face from the Loves, she saw not
Tears for laughter darken immortal eyelids, Heard not about her

Fearful fitful wings of the doves departing, Saw not how the bosom of Aphrodite
Shook with weeping, saw not her shaken raiment, Saw not her hands wrung;

Saw the Lesbians kissing across their smitten Lutes with lips more sweet than the sound of lute-strings, Mouth to mouth and hand upon hand, her chosen, Fairer than all men;

Only saw the beautiful lips and fingers, Full of songs and kisses and little whispers, Full of music; only beheld among them Soar, as a bird soars

Newly fledged, her visible song, a marvel, Made of perfect sound and exceeding passion, Sweetly shapen, terrible, full of thunders, Clothed with the wind's wings.

Then rejoiced she, laughing with love, and scattered Roses, awful roses of holy blossom; Then the Loves thronged sadly with hidden faces Round Aphrodite,

Then the Muses, stricken at heart, were silent; Yea, the gods waxed pale; such a song was that song. All reluctant, all with a fresh repulsion, Fled from before her.

All withdrew long since, and the land was barren, Full of fruitless women and music only. Now perchance, when winds are assuaged at sunset, Lulled at the dewfall,

By the grey sea-side, unassuaged, unheard of, Unbeloved, unseen in the ebb of twilight, Ghosts of outcast women return lamenting, Purged not in Lethe,

Clothed about with flame and with tears, and singing Songs that move the heart of the shaken heaven, Songs that break the heart of the earth with pity, Hearing, to hear them.

Algernon Charles Swinburne

Symbolic dance by Jan Ciągliński

A painting of Sappho--Édouard-Henri Avril

Paul-Emile Bécat

From *Fanny Hill*

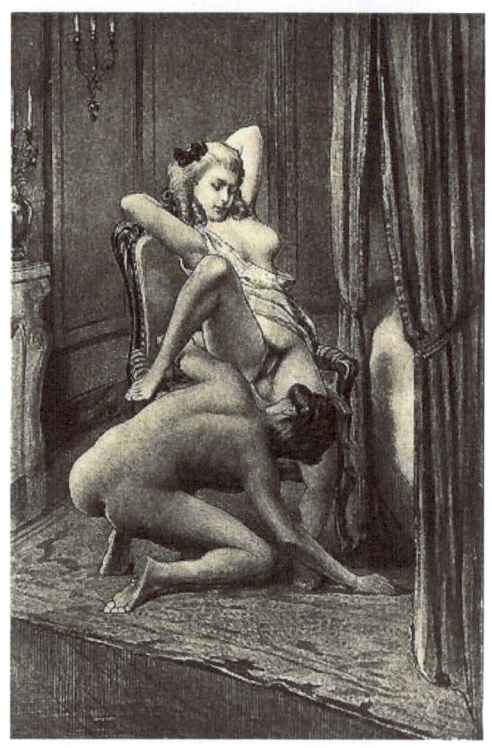

Oeuvres de Paul Verlaine

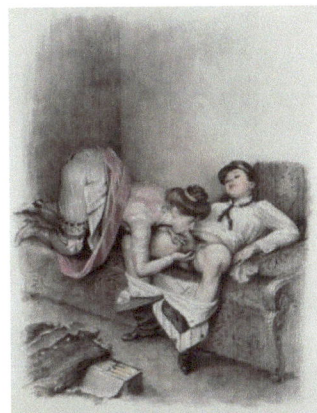

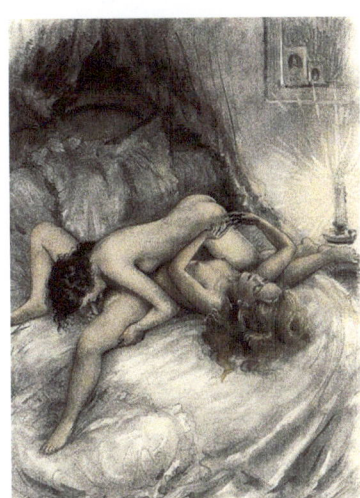

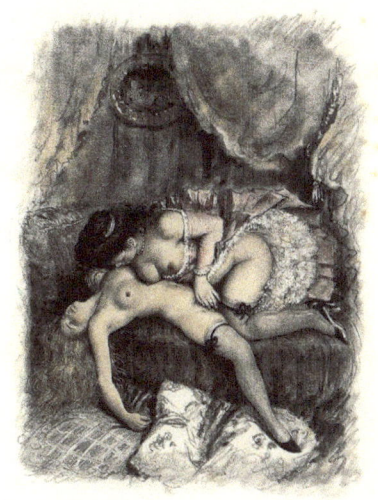

'He's equal with the Gods, that man'

He's equal with the Gods, that man

Who sits across from you,

Face to face, close enough, to sip

Your voice's sweetness,

And what excites my mind,

Your laughter, glittering. So,

When I see you, for a moment,

My voice goes,

My tongue freezes. Fire,

Delicate fire, in the flesh.

Blind, stunned, the sound

Of thunder, in my ears.

Shivering with sweat, cold

Tremors over the skin,

I turn the colour of dead grass,

And I'm an inch from dying.

'But you, O Dika, wreathe lovely garlands in your hair,'

But you, O Dika, wreathe lovely garlands in your hair,

Weave shoots of dill together, with slender hands,

For the Graces prefer those who are wearing flowers,

And turn away from those who go uncrowned.

By Sappho

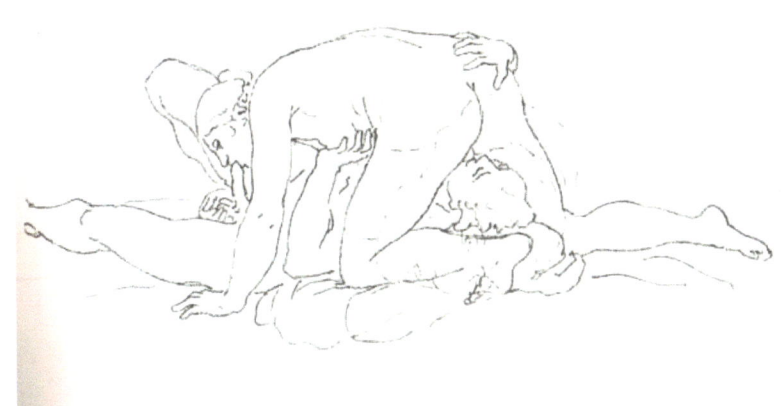

Fellatio, or oral sex performed on a man-- Francesco Hayez-- Romanticism

HER LOVER

BY MAXIM GORKY

An acquaintance of mine once told me the following story.

When I was a student at Moscow I happened to live alongside one of those ladies whose repute is questionable. She was a Pole, and they called her Teresa. She was a tallish, powerfully-built brunette, with black, bushy eyebrows and a large coarse face as if carved out by a hatchet—the bestial gleam of her dark eyes, her thick bass voice, her cabman-like gait and her immense muscular vigour, worthy of a fishwife, inspired me with horror. I lived on the top flight and her garret was opposite to mine. I never left my door open when I knew her to be at home. But this, after all, was a very rare occurrence. Sometimes I chanced to meet her on the staircase or in the yard, and she would smile upon me with a smile which seemed to me to be sly and cynical. Occasionally, I saw her drunk, with bleary eyes, tousled hair, and a particularly hideous grin. On such occasions she would speak to me.

"How d'ye do, Mr. Student!" and her stupid laugh would still further intensify my loathing of her. I should have liked to have changed my quarters in order to have avoided such encounters and greetings; but my little chamber was a nice one, and there was such a wide view from the window, and it was always so quiet in the street below—so I endured.

And one morning I was sprawling on my couch, trying to find some sort of excuse for not attending my class, when the door opened, and the bass voice of Teresa the loathsome resounded from my threshold:

"Good health to you, Mr. Student!"

"What do you want?" I said. I saw that her face was confused and supplicatory... It was a very unusual sort of face for her.

"Sir! I want to beg a favour of you. Will you grant it me?"

I lay there silent, and thought to myself:

"Gracious!... Courage, my boy!"

"I want to send a letter home, that's what it is," she said; her voice was beseeching, soft, timid.

"Deuce take you!" I thought; but up I jumped, sat down at my table, took a sheet of paper, and said:

"Come here, sit down, and dictate!"

She came, sat down very gingerly on a chair, and looked at me with a guilty look.

"Well, to whom do you want to write?"

"To Boleslav Kashput, at the town of Svieptziana, on the Warsaw Road..."

"Well, fire away!"

"My dear Boles ... my darling ... my faithful lover. May the Mother of God protect thee! Thou heart of gold, why hast thou not written for such a long time to thy sorrowing little dove, Teresa?"

I very nearly burst out laughing. "A sorrowing little dove!" more than five feet high, with fists a stone and more in weight, and as black a face as if the little dove had lived all its life in a chimney, and had never once washed itself! Restraining myself somehow, I asked:

"Who is this Bolest?"

"Boles, Mr. Student," she said, as if offended with me for blundering over the name, "he is Boles—my young man."

"Young man!"

"Why are you so surprised, sir? Cannot I, a girl, have a young man?"

She? A girl? Well!

"Oh, why not?" I said. "All things are possible. And has he been your young man long?"

"Six years."

"Oh, ho!" I thought. "Well, let us write your letter…"

And I tell you plainly that I would willingly have changed places with this Boles if his fair correspondent had been not Teresa but something less than she.

"I thank you most heartily, sir, for your kind services," said Teresa to me, with a curtsey. "Perhaps *I* can show *you* some service, eh?"

"No, I most humbly thank you all the same."

"Perhaps, sir, your shirts or your trousers may want a little mending?"

I felt that this mastodon in petticoats had made me grow quite red with shame, and I told her pretty sharply that I had no need whatever of her services.

She departed.

A week or two passed away. It was evening. I was sitting at my window whistling and thinking of some expedient for enabling me to get away from myself. I was bored; the weather was dirty. I didn't want to go out, and out of sheer ennui I began a course of self-analysis and reflection. This also was dull enough work, but I didn't care about doing anything else. Then the door opened. Heaven be praised! Some one came in.

"Oh, Mr. Student, you have no pressing business, I hope?"

It was Teresa. Humph!

"No. What is it?"

"I was going to ask you, sir, to write me another letter."

"Very well! To Boles, eh?"

"No, this time it is from him."

"Wha-at?"

"Stupid that I am! It is not for me, Mr. Student, I beg your pardon. It is for a friend of mine, that is to say, not a friend but an acquaintance—a man acquaintance. He has a sweetheart just like me here, Teresa. That's how it is. Will you, sir, write a letter to this Teresa?"

I looked at her—her face was troubled, her fingers were trembling. I was a bit fogged at first—and then I guessed how it was.

"Look here, my lady," I said, "there are no Boleses or Teresas at all, and you've been telling me a pack of lies. Don't you come sneaking about me any longer. I have no wish whatever to cultivate your acquaintance. Do you understand?"

And suddenly she grew strangely terrified and distraught; she began to shift from foot to foot without moving from the place, and spluttered comically, as if she wanted to say something and couldn't. I waited to see what would come of all this, and I saw and felt that, apparently, I had made a great mistake in suspecting her of wishing to draw me from the path of righteousness. It was evidently something very different.

"Mr. Student!" she began, and suddenly, waving her hand, she turned abruptly towards the door and went out. I remained with a very unpleasant

feeling in my mind. I listened. Her door was flung violently to—plainly the poor wench was very angry... I thought it over, and resolved to go to her, and, inviting her to come in here, write everything she wanted.

I entered her apartment. I looked round. She was sitting at the table, leaning on her elbows, with her head in her hands.

"Listen to me," I said.

Now, whenever I come to this point in my story, I always feel horribly awkward and idiotic. Well, well!

"Listen to me," I said.

She leaped from her seat, came towards me with flashing eyes, and laying her hands on my shoulders, began to whisper, or rather to hum in her peculiar bass voice:

"Look you, now! It's like this. There's no Boles at all, and there's no Teresa either. But what's that to you? Is it a hard thing for you to draw your pen over paper? Eh? Ah, and *you*, too! Still such a little fair-haired boy! There's nobody at all, neither Boles, nor Teresa, only me. There you have it, and much good may it do you!"

"Pardon me!" said I, altogether flabbergasted by such a reception, "what is it all about? There's no Boles, you say?"

"No. So it is."

"And no Teresa either?"

"And no Teresa. I'm Teresa."

I didn't understand it at all. I fixed my eyes upon her, and tried to make out which of us was taking leave of his or her senses. But she went again to the

table, searched about for something, came back to me, and said in an offended tone:

"If it was so hard for you to write to Boles, look, there's your letter, take it! Others will write for me."

I looked. In her hand was my letter to Boles. Phew!

"Listen, Teresa! What is the meaning of all this? Why must you get others to write for you when I have already written it, and you haven't sent it?"

"Sent it where?"

"Why, to this—Boles."

"There's no such person."

I absolutely did not understand it. There was nothing for me but to spit and go. Then she explained.

"What is it?" she said, still offended. "There's no such person, I tell you," and she extended her arms as if she herself did not understand why there should be no such person. "But I wanted him to be... Am I then not a human creature like the rest of them? Yes, yes, I know, I know, of course... Yet no harm was done to any one by my writing to him that I can see..."

"Pardon me—to whom?"

"To Boles, of course."

"But he doesn't exist."

"Alas! alas! But what if he doesn't? He doesn't exist, but he *might!* I write to him, and it looks as if he did exist. And Teresa—that's me, and he replies to me, and then I write to him again..."

I understood at last. And I felt so sick, so miserable, so ashamed, somehow. Alongside of me, not three yards away, lived a human creature who had nobody in the world to treat her kindly, affectionately, and this human being had invented a friend for herself!

"Look, now! you wrote me a letter to Boles, and I gave it to some one else to read it to me; and when they read it to me I listened and fancied that Boles was there. And I asked you to write me a letter from Boles to Teresa—that is to me. When they write such a letter for me, and read it to me, I feel quite sure that Boles is there. And life grows easier for me in consequence."

"Deuce take you for a blockhead!" said I to myself when I heard this.

And from thenceforth, regularly, twice a week, I wrote a letter to Boles, and an answer from Boles to Teresa. I wrote those answers well... She, of course, listened to them, and wept like anything, roared, I should say, with her bass voice. And in return for my thus moving her to tears by real letters from the imaginary Boles, she began to mend the holes I had in my socks, shirts, and other articles of clothing. Subsequently, about three months after this history began, they put her in prison for something or other. No doubt by this time she is dead.

My acquaintance shook the ash from his cigarette, looked pensively up at the sky, and thus concluded:

Well, well, the more a human creature has tasted of bitter things the more it hungers after the sweet things of life. And we, wrapped round in the rags of our virtues, and regarding others through the mist of our self-sufficiency, and persuaded of our universal impeccability, do not understand this.

And the whole thing turns out pretty stupidly—and very cruelly. The fallen classes, we say. And who are the fallen classes, I should like to know? They are, first of all, people with the same bones, flesh, and blood and nerves as ourselves. We have been told this day after day for ages. And we actually listen—and the devil only knows how hideous the whole thing is. Or are we

completely depraved by the loud sermonising of humanism? In reality, we also are fallen folks, and, so far as I can see, very deeply fallen into the abyss of self-sufficiency and the conviction of our own superiority. But enough of this. It is all as old as the hills—so old that it is a shame to speak of it. Very old indeed—yes, that's what it is!

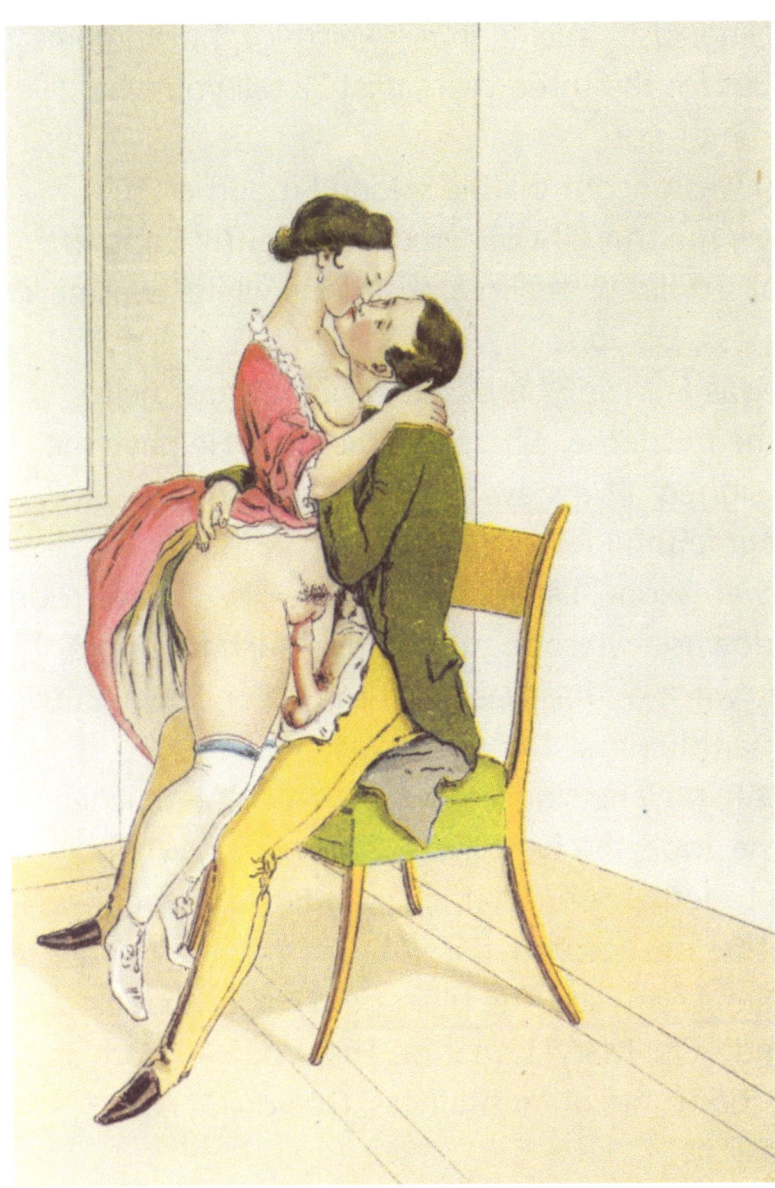

Das Liebespaar (The Lovers) by Peter Fendi

THE FAITHFUL LOVERS.

F. C. Burnand.

I'd been away from her three years—about that— And I returned to find my Mary true, And though I'd question her, I did not doubt that It was unnecessary so to do.

'Twas by the chimney corner we were sitting, "Mary," said I, "have you been always true?" "Frankly," says she, just pausing in her knitting, "I *don't* think I've unfaithful been to you; But for the three years past I'll tell you what I've done; then say if I've been true or not.

"When first you left, my grief was uncontrollable, Alone I mourned my miserable lot, And all who saw me thought me inconsolable, Till Captain Clifford came from Aldershot; To flirt with him amused me while 'twas new, I don't count *that* unfaithfulness. Do you?

"The next—oh! let me see—was Frankie Phipps, I met him at my uncle's Christmas-tide; And 'neath the mistletoe, where lips met lips, He gave me his first kiss"—and here she sighed; "We stayed six weeks at uncle's—how time flew! I don't count *that* unfaithfulness. Do you?

"Lord Cecil Fossmote, only twenty-one, Lent me his horse. Oh, how we rode and raced! We scoured the downs—we rode to hounds—such fun! And often was his arm around my waist— That was to lift me up or down. But who Would count *that* as unfaithfulness? Do you?

"Do you know Reggy Vere? Ah, how he sings! We met—'twas at a picnic. Ah, such weather! He gave me, look, the first of these two rings, When we were lost in Cliefden Woods together. Ah, what a happy time we spent, we two! I don't count *that* unfaithfulness to you. [Pg 96]

"I've yet another ring from him. D'you see The plain gold circlet that is shining here?" I took her hand: "Oh, Mary! Can it be That you"—Quoth she, "that I am Mrs. Vere. I don't count *that* unfaithfulness. Do you?" "*No,*" *I replied, "for I am married, too."*

Overlapping wife back position on the swing--Francesco Hayez--Romanticism

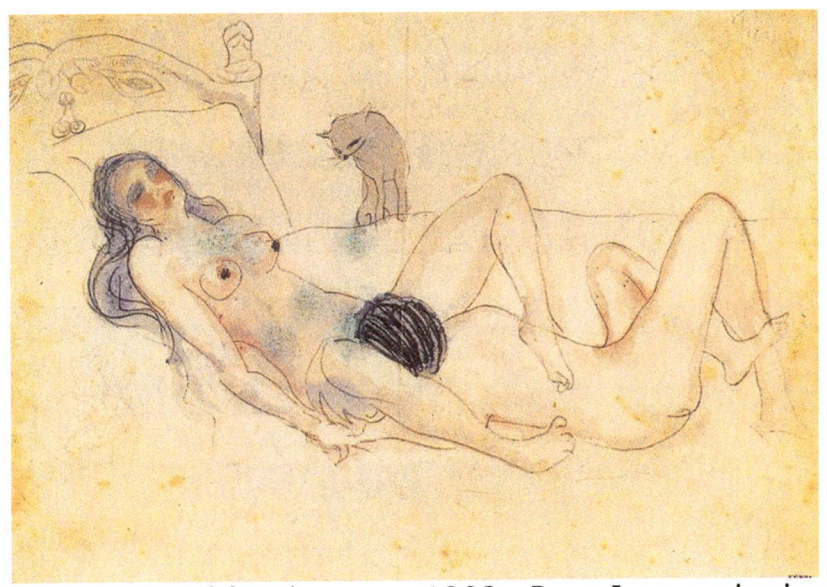

Two nudes and a cat--Pablo Picasso—1903--Post-Impressionism

HINTS FOR LOVERS

by Arnold Haultain

VI. On Making Love

"Mille modi Veneris"
—Ovid

There are as many ways of making love as there are of making soup. And probably

There are as many kinds of love as there are of flavors. And

Palates—both sentimental and physical—evidently differ widely. And yet,

If you would know the secret of success with women, it is said in a word: Ardor. And

Would ye, O women, know in a word the secret of success with men? It lies in: Responsiveness.

* * *

In matters amatory—or rather pre-amatory—feminine tactics are infallible and consummate:

Let no man think to cope with feminine strategy.

* * *

A rake has more chance than a ninny.—Which doubtless has been said before.

In love, as in all things, indecision spells ruination. For

There is a curious antagonism between the sexes. They are in a manner foes, not friends. The successful wooer is the captor, the raptor; the bride is the capture, the rapture. (1) And

Even she who is minded to be caught will not spare her huntsman the ardor of the chase, and lightly esteems him who imagines she is to be lightly won.

In the chess-like game of love-making, no woman plays for check-mate: the game interests her too much to bring it to a finish. What pleases her most is stale-mate, where, though the King cannot be captured, the captress can maneuver without end.

A man imagines he wins by strenuous assault. The woman knows the victory was due to surrender.

(1) Etymologically as well as metaphorically—and veritably.

* * *

Wouldst thou ask ought of a woman? Question her eyes: they are vastly more voluble than her tongue. Indeed,

There is no question too subtle, too delicate, too recondite, or too rash, for human eyes to ask or answer. And

He who has not learned the language of the eyes, has yet to learn the alphabet of love. Besides,

Love speaks two languages: one with the lips; the other with the eyes. (There is really a third; but this is Pentecostal.) At all events,

Lovers always talk in a cryptic tongue.

There is but one universal language: the ocular—not Volapuk nor Esperanto is as intelligible or as efficacious as this.

* * *

No woman can be coerced into love,—though she may be coerced into marriage. And

Man, the clumsy wielder of one blunt weapon, often enough stands agape at his own powerlessness before the invulnerable woman of his desire. Indeed,

The battle between the coquettish maid and determined man is like the battle between the Retiarius and the Mirmillio. The coquetry ensnares the man as with a net against which his sword is useless.

* * *

A woman's emotions are as practical as a man's reason.

A man's emotions are never practical. This is why,

In the emotional matter of love, men and women so often lash. And perhaps

It is a beneficial thing for the race that a woman's emotions are practical. For

If neither the man nor the woman curbed the mettlesome Pegasus "Emotion", methinks the colts and fillies would want for hay and oats. * * *

It is a moot question which is the more fatally fascinating: the uniformed nurse or the weeded widow. But

Who has yet discovered the secret springs of fascination? For example,

How is it that certain eyes and lips will enthrall, while others leave us cold and inert?

Does the potency lie in the eyes and the lips, or is there some inscrutable and psychic power? At all events, who will explain how it is that

A man will sometimes forsake the most beautiful of wives and a woman will forsake the kindest of husbands to follow recklessly one who admits no comparison with the one forsaken? All we can say is that

The potency of personality exceeds the potency of beauty. For, Powerful as is physical charm, it counts not for all in the matter of love. Yet what it may be that does count, and how and why it does count, no man living shall say. For

Is even love aware of all its seeks? And

Is it given to any to grant all that love beseeches? And yet

Were all love sought bestowed, what sequel?

Perhaps 't were well to leave love but semi-satisfied. At bottom the real question is this: What will win and keep me another heart? But

How to win and keep another heart, that is a thing has to be found out for oneself—if it be discoverable. And always by the experimental method. Since

In matters amatory, there is no a priori reasoning possible. All we know is that

There is nothing more potent than passion. And

The chasm, which seems to innocence to yawn between virtue and frailty, is leapt by that Pegasus, Passion, at a bound—but he blinds his rider in the feat.

* * *

In spite of the poesy of love, deeds are more potent than words; —though perhaps it is well to pave the way for the one by the other.

In spite, too of the piety of love, love laughs at promises—that is, the promises that affect it.

* * *

There is one miracle that women can always perform, and always it astonishes the man; it is this: to change from the recipient into the appellant. That is to say,

When woman, usually regarded as the receiver, becomes the giver,—or rather the demander,—man's wonderment surpasses words. And let it be remembered that

There is no re-crossing this Rubicon.

* * *

Mistrust a prolonged and obdurate resistance. Either you are out-classed, or you are out-experienced. And, besides,

Surrender after prolonged resistance rarely is brought about by emotion.

* * *

A woman never really quite detests daring. This is why
Much is a forgiving a daring man. So, too,

Much is forgiven a pretty woman by the men.

* * *

If the beginning of strife is as when one letteth out water, the beginning of love is as when one kindleth a fire.

The eye tells more than the tongue. And

If the eye and the tongue contradict each other, believe the eye.

There is an indifference that attracts, and there is an indifference that repels. He is a sagacious man, and she is a sagacious woman, who will differentiate them. The question resolves itself into that which so often puzzles the angler,—how much line to let out. About one thing there need be no hesitation,

When your fish is within reach, be quick with the landing-net—or even with the gaff.

* * *

In the matter of wooing, soon enough does the young girl learn to prefer the mature manners of the man of the world to the gaucheries of inexperienced youth. As to the man!

How curious the things that appeal to this lord of creation, Man!—a half-averted face—a laughing gesture—a merry eye—an all but imperceptible tone of the voice—the scarce felt touch of a reluctant hand—a semi-tender phrase—an unexpected glance—the momentary pressure of petulant lips—a blanched cheek—a look prolonged one fractional part of a second beyond its wont—an infinitesimal drooping of the eyelid—a speaking silence—a half-caught sigh—these will entrap the male brute where green widths that were never dried will not hold him. But

By what men are won, most women seem thoroughly to comprehend.

By what women are won, few men know. Perhaps

No woman knows by what she herself is won.

One thing there is, at all events, to which woman will always succumb: tenderness. But remember, Dames, that

Tenderness is extremely difficult of simulation. Or rather,

Tenderness is so delicate and deep-seated a feeling, that few care to attempt its simulation.

* * *

A woman who gives herself too freely is apt to regret the giving. In time, too, she discovers that, as a matter of fact,

No woman can give her real self twice: one or other gift will prove to be a loan. (And

It is always and only the first recipient that causes a woman's heart to flutter, and often it flutters long.) 144

A second gift is generally a mortgage—if it is not a sale.

A mortgage is difficult to bind. For

There is a statute of limitations in love as there is in law. Nor is the former to be set aside by bond.

That pair is in a parlous state when either party discovers that the title was not properly searched. Since

Everybody expects a fee simple,—though few deserve it, God wot!

* * *

Perhaps the most durable conquest is the incomplete one. Which sounds illogical. But it is well to remember that

Repletion seems to cause, in the man, temporary indifference; while

Repletion causes, in the woman, enduring content. And in this we can detect a significant distinction between the sexes: namely the fact that

A single goal satisfies most women;

No single goal ever yet satisfied the restless spirit of man.

* * *

What gives keenest joy is the evocation of latent passion. For Each takes pleasure in believing that he or she alone can evoke this passion. Accordingly,

The premature confession of passion, and the confession of premature passion, both rankle in the breast—and, probably, in the breast of both penitent and confessor.

* * *

What intensity of feeling a woman can throw into the enunciation of a Christian name! There is perhaps no better clue to possession that this. For, probably,

Not until a man's Christian mane is ecstatically uttered is a woman wholly his. * * *

Men and women content with the different weapons. This is why Men are rarely intrepid in the presence of women; but women rarely stand in awe of men.—Nothing differentiates the sexes more than this; but the psychological reason is difficult to discover. Perhaps,

The making of love is a sort of duel, the conditions of which are that the man shall doff all his armor and the woman may don all hers. Indeed,

The battle of love-making would be an unequal combat, even were both contestants fully panoplied; for,

A woman's derision will pierce any mail. In fact,

No armor is impervious to woman's shafts—be they those of laughter or be they those of love. So

The veriest roué' is vulnerable to the veriest maid. But

For each man she meets, a woman carries in her quiver but one shaft. If that misses its aim, she is powerless: it is like a dart without a thong; when thrown, the man can close. But

Always it devolves upon the man to take the initiative. But, again,

Always the man must pretend that he takes no initiative. But, again,

Always the woman must pretend that she gives no opportunity.

The game of love is not only one of chance but one of skill. What irks man is that a woman pretends that she must be circumvented by wiles. But

Man was ever a clumsy wooer. Nevertheless,

It is only the man who thinks he is too venturesome. Since

The iciest woman sometimes thaws. And

The austerer a woman, the sweeter her surrender. And, again,
A woman is never sweeter than in surrender. Accordingly,

"De l'audace, et encore de l'audace, et toujours de l'audace"(2) should be the motto of every wooer. Since

Audacity if beloved of women; but it must be an audacity born of Sincerity and educated b y Discretion. At all events

Beware timidity,—it is fatal.

(2) Danton

* * *

With women, nothing is more conquering than conquest; nothing so irresistible as resistance. On the other hand,

Resistance on the part of the woman is an effort put forth for the purpose of defeating its own object.

* * *

A man prizes only what he has fought for. No one knows this better than a woman. This is why

A woman's capitulation she always makes to appear as a capture. And

Where there are no defense works, a woman will erect them.

Foolish that man who does not storm entrenchments. For

Resistance on the part of a woman is a wall which a man is expected to leap. His agility is the measure of her approbation.

* * *

Arouse a woman's interest, and you arouse much. But
Having failed, disappear. Yet

It takes very many futile attempts to make a failure. At the same time,

Importunity is an inferior weapon.

* * *

A conditional surrender is no surrender. But

A woman's surrender is in reality a desertion, a going over to the enemy. Thenceforward she is an ally. Indeed

A woman's capitulation is her conquest.

* * *

Let no amount of simulated austerity deter you. The marble Galatea came to life at the prayer of a man.

* * *

The number of modes in which a woman can say 'Yes' has not, up to the present, be accurately enumerated; but perhaps the one most frequently in use is the negative imperative. And

Many are the men who have puzzled long and painfully over the motives of a woman's 'No.' Yet in nine cases out of ten a woman says 'No' merely because she feels herself on the brink of saying 'Yes'. In other words,

It is often mistrust of herself that leads many a woman to refuse it will the lips the consent that is fluttering at her heart. Perhaps that is why

With woman 'Yea' and 'Nay' are meaningless and interchangeable terms.

* * *

'Ware a show of excessive feeling. It is proof, either that it is shallow and evanescent, or that it is put on. At all events Excessive feeling is rarely taken seriously. Now

Seriousness adds a spice to gallantry. But, like spice, a little is ample.

* * *

Many men think it is the woman who has to be persuaded. It is not the woman; it is her scruples. Besides, "Nemo repente turpissimus—vel turpissima". Yet

By thirty, scruples are either dormant or dominant.

Both of the callow youth of fifteen and the man of the world of forty-five swear by the woman of thirty.

* * *

It may seem a paradox, but it is a truism, that, in matters of love, it is the weaker and the defenseless sex that takes the initiative. In other words,

The woman makes the opportunity which the man takes. And

An opportunity missed is an opportunity lost. And

The woman is implacable to the man who sees the opportunity and takes it not. Since

With woman indifference is worse than insult. Wherefore

Never, never disappoint a woman.

* * *

Spontaneous admiration is the sincerest flattery. Those who know this, affect spontaneity. But it requires much art to conceal this art.

You will oftener err upon the side of ultra-delicacy in a compliment that upon the side of bare-facedness.

Do not imagine that excessive admiration can give offence. But remember that

The eye can netter express admiration than can the tongue.

The publicity with which a woman will receive admiration from a male admirer 144 often is sufficient to astonish that admirer. But

Often enough it is the admiration, not the admirer, that a woman covets. Indeed,

Many a woman is in love with love (3), but not her lover. But this no lover can be got to comprehend.

To flatter by deprecating a rival is a complement of extremely doubtful efficacy.

(3) I seem to remember that somebody before has said something like this before.

* * *

A woman does not admire too clement a conqueror. She admits the right to ovation, and to him who waives it she lightly regards.

* * *

Seek no stepping-stones unless you mean to cross:

He who gathers stepping-stones and refrains from crossing is contempted of women. Indeed,

Every advance of which advantage is not taken, is in reality a retreat. And remember, too, that though

Sought interviews are sweet, those unsought are sweeter. And

Probably no son of Adam—and for the matter of that, probably no daughter of Eve—ever quite looks back with remorse upon a semi-innocent escapade. Yet

The man who thinks he can at any time extract himself from any feminine entanglement that he may choose to have raveled, is a simpleton.

* * *

The way of man with a maid may have been too wonderful for Agur; now-a-days the way of a man with a married woman would puzzle a wiser than he.

What is the attitude to be maintained towards the too complaisant spouse of an honorable friend? That is a problem will puzzle weak men without end. Of that fatal and fateful dilemma when a wife or a husband falls victim to the wiles of another, there are, for the delinquent, two and only two horns (and it is a moot question upon which it is preferable to be impaled): Flight—either from the victor or the victrix. Yet

To some it is no anomaly to pray God's blessing upon a liaison. But these folk are to be pitied; for

A clandestine love always works havoc—havoc to all three. (4)

(4) Cf. Platus: "Malus clandestinus est amor; damnum 'st merum."

Will men and women never learn what trouble they lay up in store for themselves by breaking their plighted troths?

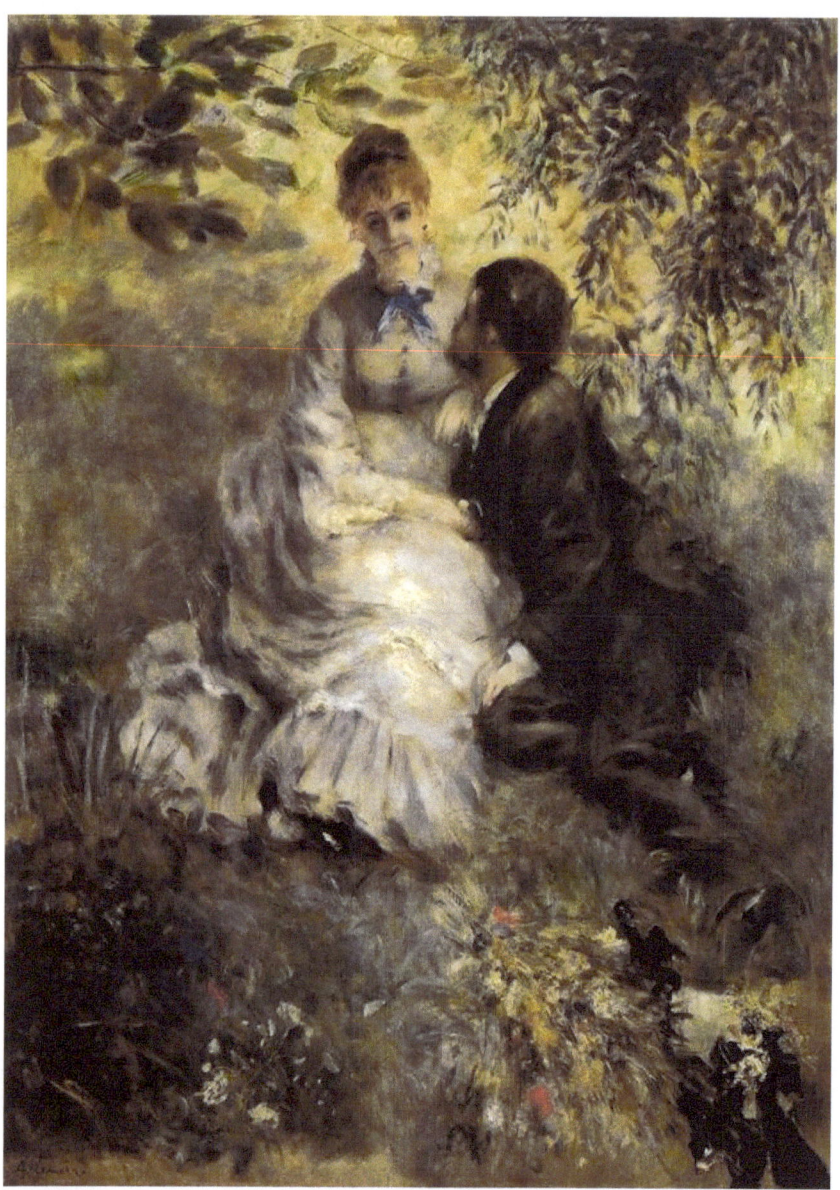

The Lovers-- Pierre-Auguste Renoir—1875--Impressionism

Miriam's Lover

Lucy Maud Montgomery

Lucy Maud Montgomery Short Stories, 1896 to 1901

I had been reading a ghost story to Mrs. Sefton, and I laid it down at the end with a little shrug of contempt.

"What utter nonsense!" I said.

Mrs. Sefton nodded abstractedly above her fancywork.

"That is. It is a very commonplace story indeed. I don't believe the spirits of the departed trouble themselves to revisit the glimpses of the moon for the purpose of frightening honest mortals—or even for the sake of hanging around the favourite haunts of their existence in the flesh. If they ever appear, it must be for a better reason than that."

"You don't surely think that they ever do appear?" I said incredulously.

"We have no proof that they do not, my dear."

"Surely, Mary," I exclaimed, "you don't mean to say that you believe people ever do or can see spirits—ghosts, as the word goes?"

"I didn't say I believed it. I never saw anything of the sort. I neither believe nor disbelieve. But you know queer things do happen at times—things you can't account for. At least, people who you know wouldn't lie say so. Of course, they may be mistaken. And I don't think that everybody can see spirits either, provided they are to be seen. It requires people of a certain organization—with a spiritual eye, as it were. We haven't all got that—in fact, I think very few of us have. I dare say you think I'm talking nonsense."

"Well, yes, I think you are. You really surprise me, Mary. I always thought you the least likely person in the world to take up with such ideas. Something must have come under your observation to develop such theories in your practical head. Tell me what it was."

"To what purpose? You would remain as sceptical as ever."

"Possibly not. Try me; I may be convinced."

"No," returned Mrs. Sefton calmly. "Nobody ever is convinced by hearsay. When a person has once seen a spirit—or thinks he has—he thenceforth believes it. And when somebody else is intimately associated with that person and knows all the circumstances—well, he admits the possibility, at least. That is my position. But by the time it gets to the third person—the outsider—it loses power. Besides, in this particular instance the story isn't very exciting. But then—it's true."

"You have excited my curiosity. You must tell me the story."

"Well, first tell me what you think of this. Suppose two people, both sensitively organized individuals, loved each other with a love stronger than life. If they were apart, do you think it might be possible for their souls to communicate with each other in some inexplicable way? And if anything happened to one, don't you think that that one could and would let the spirit of the other know?"

"You're getting into too deep waters for me, Mary," I said, shaking my head. "I'm not an authority on telepathy, or whatever you call it. But I've no belief in such theories. In fact, I think they are all nonsense. I'm sure you must think so too in your rational moments."

"I dare say it is all nonsense," said Mrs. Sefton slowly, "but if you had lived a whole year in the same house with Miriam Gordon, you would have been tainted too. Not that she had 'theories'—at least, she never aired them if she had. But there was simply something about the girl herself that gave a

person strange impressions. When I first met her I had the most uncanny feeling that she was all spirit—soul—what you will! no flesh, anyhow. That feeling wore off after a while, but she never seemed like other people to me.

"She was Mr. Sefton's niece. Her father had died when she was a child. When Miriam was twenty her mother had married a second time and went to Europe with her husband. Miriam came to live with us while they were away. Upon their return she was herself to be married.

"I had never seen Miriam before. Her arrival was unexpected, and I was absent from home when she came. I returned in the evening, and when I saw her first she was standing under the chandelier in the drawing room. Talk about spirits! For five seconds I thought I had seen one.

"Miriam was a beauty. I had known that before, though I think I hardly expected to see such wonderful loveliness. She was tall and extremely graceful, dark—at least her hair was dark, but her skin was wonderfully fair and clear. Her hair was gathered away from her face, and she had a high, pure, white forehead, and the straightest, finest, blackest brows. Her face was oval, with very large and dark eyes.

"I soon realized that Miriam was in some mysterious fashion different from other people. I think everyone who met her felt the same way. Yet it was a feeling hard to define. For my own part I simply felt as if she belonged to another world, and that part of the time she—her soul, you know—was back there again.

"You must not suppose that Miriam was a disagreeable person to have in the house. On the contrary, it was the very reverse. Everybody liked her. She was one of the sweetest, most winsome girls I ever knew, and I soon grew to love her dearly. As for what Dick called her 'little queernesses'—well, we got used to them in time.

"Miriam was engaged, as I have told you, to a young Harvard man named Sidney Claxton. I knew she loved him very deeply. When she showed me his photograph, I liked his appearance and said so. Then I made some teasing remark about her love-letters—just for a joke, you know. Miriam looked at me with an odd little smile and said quickly:

"'Sidney and I never write to each other.'

"'Why, Miriam!' I exclaimed in astonishment. 'Do you mean to tell me you never hear from him at all?'

"'No, I did not say that. I hear from him every day—every hour. We do not need to write letters. There are better means of communication between two souls that are in perfect accord with each other.'

"'Miriam, you uncanny creature, what do you mean?' I asked.

"But Miriam only gave another queer smile and made no answer at all. Whatever her beliefs or theories were, she would never discuss them.

"She had a habit of dropping into abstracted reveries at any time or place. No matter where she was, this, whatever it was, would come over her. She would sit there, perhaps in the centre of a gay crowd, and gaze right out into space, not hearing or seeing a single thing that went on around her.

"I remember one day in particular; we were sewing in my room. I looked up and saw that Miriam's work had dropped on her knee and she was leaning forward, her lips apart, her eyes gazing upward with an unearthly expression.

"'Don't look like that, Miriam!' I said, with a little shiver. 'You seem to be looking at something a thousand miles away!'

"Miriam came out of her trance or reverie and said, with a little laugh:

"'How do you know but that I was?'

"She bent her head for a minute or two. Then she lifted it again and looked at me with a sudden contraction of her level brows that betokened vexation.

"'I wish you hadn't spoken to me just then,' she said. 'You interrupted the message I was receiving. I shall not get it at all now.'

"'Miriam,' I implored. 'I so wish my dear girl, that you wouldn't talk so. It makes people think there is something queer about you. Who in the world was sending you a message, as you call it?'

"'Sidney,' said Miriam simply.

"'Nonsense!'

"'You think it is nonsense because you don't understand it,' was her calm response.

"I recall another event was when some caller dropped in and we had drifted into a discussion about ghosts and the like—and I've no doubt we all talked some delicious nonsense. Miriam said nothing at the time, but when we were alone I asked her what she thought of it.

"'I thought you were all merely talking against time,' she retorted evasively.

"'But, Miriam, do you really think it is possible for ghosts—'

"'I detest that word!'

"'Well, spirits then—to return after death, or to appear to anyone apart from the flesh?'

"'I will tell you what I know. If anything were to happen to Sidney—if he were to die or be killed—he would come to me himself and tell me.'

"One day Miriam came down to lunch looking pale and worried. After Dick went out, I asked her if anything were wrong.

"'Something has happened to Sidney,' she replied, 'some painful accident—I don't know what.'

"'How do you know?' I cried. Then, as she looked at me strangely, I added hastily, 'You haven't been receiving any more unearthly messages, have you? Surely, Miriam, you are not so foolish as to really believe in that!'

"'I know,' she answered quickly. 'Belief or disbelief has nothing to do with it. Yes, I have had a message. I know that some accident has happened to Sidney—painful and inconvenient but not particularly dangerous. I do not know what it is. Sidney will write me that. He writes when it is absolutely necessary.'

"'Aerial communication isn't perfected yet then?' I said mischievously. But, observing how really worried she seemed, I added, 'Don't fret, Miriam. You may be mistaken.'

"Well, two days afterwards she got a note from her lover—the first I had ever known her to receive—in which he said he had been thrown from his horse and had broken his left arm. It had happened the very morning Miriam received her message.

"Miriam had been with us about eight months when one day she came into my room hurriedly. She was very pale.

"'Sidney is ill—dangerously ill. What shall I do?'

"I knew she must have had another of those abominable messages—or thought she had—and really, remembering the incident of the broken arm, I couldn't feel as sceptical as I pretended to. I tried to cheer her, but did not succeed. Two hours later she had a telegram from her lover's college chum, saying that Mr. Claxton was dangerously ill with typhoid fever.

"I was quite alarmed about Miriam in the days that followed. She grieved and fretted continually. One of her troubles was that she received no more messages; she said it was because Sidney was too ill to send them. Anyhow,

she had to content herself with the means of communication used by ordinary mortals.

"Sidney's mother, who had gone to nurse him, wrote every day, and at last good news came. The crisis was over and the doctor in attendance thought Sidney would recover. Miriam seemed like a new creature then, and rapidly recovered her spirits.

"For a week reports continued favourable. One night we went to the opera to hear a celebrated prima donna. When we returned home Miriam and I were sitting in her room, chatting over the events of the evening.

"Suddenly she sat straight up with a sort of convulsive shudder, and at the same time—you may laugh if you like—the most horrible feeling came over me. I didn't see anything, but I just felt that there was something or someone in the room besides ourselves.

"Miriam was gazing straight before her. She rose to her feet and held out her hands.

"'Sidney!' she said.

"Then she fell to the floor in a dead faint.

"I screamed for Dick, rang the bell and rushed to her.

"In a few minutes the whole household was aroused, and Dick was off posthaste for the doctor, for we could not revive Miriam from her death-like swoon. She seemed as one dead. We worked over her for hours. She would come out of her faint for a moment, give us an unknowing stare and go shudderingly off again.

"The doctor talked of some fearful shock, but I kept my own counsel. At dawn Miriam came back to life at last. When she and I were left alone, she turned to me.

"'Sidney is dead,' she said quietly. 'I saw him—just before I fainted. I looked up, and he was standing between me and you. He had come to say farewell.'

"What could I say? Almost while we were talking a telegram came. He was dead—he had died at the very hour at which Miriam had seen him."

Mrs. Sefton paused, and the lunch bell rang.

"What do you think of it?" she queried as we rose.

"Honestly, I don't know what I think of it," I answered frankly.

Lucy Maud Montgomery Short Stories, 1896 to 1901

Lovers--Ernst Ludwig Kirchner—1909-- Expressionism

Viola's Lovers

A Study in the New Morality

By Richard Bowland Kimball

I SOMETIMES think that our relations with our children, or our pets, are successful because we expect nothing in return. Yet, after all, the relations are reciprocal; and I have been thinking today of some of the things I have got from an old dog who has been in our family for years and years. I have learned several spiritual truths from her, and I have learned them more thoroughly, perhaps, because she never had the slightest idea that she was teaching me anything. Dogs, of course, show various characteristics—some are snobs, others take naturally to a low life, others again are aristocratic and reticent and self-controlled; but I have never known a dog yet that you could describe as exactly a moralist.

Viola came to us out of the primeval woods with an effect of apparitional beauty. Rather a poetic name for a dog, perhaps; but there was such a union of grace and timidity, such a charm of silken draperies and russet ruff and tail almost sweeping the ground, that we were irresistibly reminded of a Viola we had seen recently. It was as if the dog said mutely, 'What should I do in Illyria?'

She had evidently been through a terrible experience. A broken rope was around her neck; she was as gaunt as a wolf; her eyes were almost iridescent with terror, like the wonderful eyes of some hysteriacs.

Imprison her soft hand and let her rave,
And feed deep, deep upon her peerless eyes!

We did not adopt Viola; she adopted us. She followed us to the tent where we were spending the summer, and there she stayed with us, to remain on guard when we were away, to welcome us on our return with such a show

of abject gratitude. I think a male dog could not have shown such a union of love and fear; her spirit had evidently been broken; it became our task to lure her confidence back again—and here began my own education. If I spoke with—well, decision to my wife, poor Viola slunk to the ground. She thought the tone was meant for her. I would never claim to be a model husband, but I did learn from Viola, theoretically at least, that one can have good manners even in the privacy of the family circle.

More rapidly than we could have expected Viola's terrors left her, and she resumed the normal canine outlook on life-like humans I have known who have managed to counteract the false starts of their early childhood—obsessions regarding dark closets, snakes, or an avenging Deity.

I am not going to dwell on the intelligence Viola manifested after she had freed herself from fear. All dogs are wonderful, even when they are not intelligent. The most stupid dog I know mopes around the house and refuses to eat whenever his master is away, thus evincing an emotional sensibility more valuable than the smartness of the most Frenchified of poodles that ever trod the vaudeville stage. Unlike a collie of my acquaintance, Viola did not keep the woodbox replenished; nor had she a vocabulary of several hundred words, like another collie that I know. Still, she had an aptitude to learn spelling. When it was inadvisable to take her out for a walk, we spelled the words, vainly trying to conceal the fact from her, as we would from a child; and often, to this day, people stop me on the road, and ask if I am the owner of the dog that knows how to spell.

What I want to dwell on is my own education rather than Viola's, and this began in earnest after we had moved to the real country, and lived in a little farmhouse without any farm. Viola was a lovely ornament to the dooryard; but it seemed a pity that there were no flocks or herds to evoke her ministering care. We didn't even keep chickens; we were ostensibly in the country to cultivate thoughts,—such as they were,—and while Viola might be said to inspire thoughts, they hardly gave her the necessary exercise. A collie should have a run of ten miles every day, and it was pathetic to see

Viola lying in the dooryard, ears erect, eyes eager, watching, waiting, hoping for something to happen. I should not be surprised if her very eagerness attracted the thing she longed for.

Our next-door neighbor, a man fully as fond of dogs as myself, was early attracted to her. He had recently lost his own dog, and asked if he might borrow Viola to help him catch his chickens, and if she might accompany him on the long drive he took every day through the countryside. With perfect good will, and in utter innocence, I consented. Little did I dream, as they say in the novels, of what lay before me.

I had an idea that Viola would understand that she was merely loaned for these expeditions; that she would come back from them with undiminished loyalty, grateful to me for having given her a chance for exercise. But our friendly neighbor had a very taking way with dogs. Aside from the wonderful trips, which were enough to turn the head of any collie, he knew how to talk dog-language better than I did. He knew how to pinch a dog's ear in the most seductive manner. With him, doggishness was both an art and a science.

There was nothing lovelier than the sight of Viola rounding up the chickens, shepherding them into their houses, holding down a recalcitrant pullet with her paw, or bringing in her mouth a dowager hen to her foster-father. If I had the gift of a sculptor and wished to carve a personification of pride, I think I should depict Viola bringing in a chicken—her tail aloft, like a plume of triumph, her eyes shining, stepping over imaginary obstacles like a high-manège horse with an air of dignity that was really ludicrous. If an unlucky chicken got away from her, away she went across meadows, and over walls, her beautiful voice vibrating through the landscape, sometimes breaking to an octave higher in her excitement.

It was fun to see her scour ahead of the wagon when her new master took her out to help him pick up eggs. It was charming to see her come home sitting on the seat beside him, tired but still eager, looking to right and left, sniffing the air, learning all sorts of smell secrets which are closed forever to

our supposedly superior human consciousness. Is it any wonder that it was necessary for me to go next door to get her, and that she followed me along the path with a certain droopy air that was hardly flattering?

There is not much in the literary life that would interest an outdoor dog. I felt somewhat like a dry-as-dust professor married to a young and attractive wife who is being taken to all the routs and parties throughout the neighborhood by a disgustingly youthful and handsome cavalier. I know nothing quite so shriveling to the soul as jealousy, nor anything so hard to fight against. I reasoned that Viola's expeditions were doing her good, that I ought to be grateful for them, and I repeated the antediluvian fallacy that my jealousy was only indicative of my love. Nothing that I could say to myself made any difference; and if I were in danger of forgetting how I felt, there were plenty of other persons to remind me.

'Well,' said the fisherman, 'I guess you don't know whether that dog is yours or Lysander's!' And my most intimate friend remarked genially, 'If I had a dog, I'd want it to be *my* dog, or I wouldn't want to have any.'

It was bad enough to bear the sympathy of the community; it was worse to witness the triumph of my rival. Often, after I had brought home the drooping Viola, Lysander would follow after her. Instantly she revived like flowers in water. She smiled, she was even coquettish. They began a lengthy conversation I could not understand—little sounds from him, little grunts from her. If, by any chance, through a belated sense of duty, she happened to remain beside my chair, he surreptitiously snapped his fingers and made little sucking sounds that he fancied were inaudible, and then she sidled over to his chair.

If jealously is an index of one's love, it is strange that, the more jealous I became of Lysander, the less I loved Viola. 'Well, *let* her stay with him,' I said to myself. 'I guess he won't object to having me pay for the license.'

She did stay; she sometimes stayed all night; and few things in my life have been more humiliating than my visits to get her.

Lysander was glad to see me—oh my, yes! He welcomed me with a crooked sardonic smile that I understood thoroughly. Viola knew just as well as he did why I had come, and pretended to take an interest in the wall-paper. As we walked home along the path, I scolded her, and she slunk to the ground and asked my pardon. Was there anything in her life that could make her conscious of any evil? Of course not. Without realizing it, I was exercising a sort of spiritual coercion over her. I was really condemning her for what was a true expression of collie life; but she accepted my suggestion of evil. I have often wondered since, how many persons in the human realm are suffering from a sense of sin as false as hers was. Of course, I did not philosophize the situation at the time. I simply felt disquietude when I was with her. This disquietude increased rapidly until I apparently disliked her; and I suppose that in my feeling for her there was actually an element of hate.

'Very well,' I said to myself in effect, 'there are better dogs in the world than ever were licensed. The next one I get, I'll keep for my very own.'

I had now reached my low spot—a centre of indifference; and if this were fiction, the reader might expect an ever-increasing objective crescendo from this point onward, culminating in a stirring climax. Possibly Viola would rescue me from a burning building, thus showing that she really loved me, after all. Unfortunately I am dealing with facts of a rather intangible nature. I have noticed that in life coffee and pistols for two are not called for so often as in literature. We pass the time of day with an acquaintance, discuss the play, and what not, little dreaming that behind that smiling exterior a spiritual crisis may be taking place.

My crisis was rather interesting because it seemed almost physical. Not so much in the subconscious brain ganglia as in the sympathetic nerve-centres, the process was taking place—the reverse process of what had taken place during my period of jealousy. I could almost hear a spiritual clicking going on inside me, as if I were composed of children's blocks which had become disarranged and were being replaced in a symmetrical

pattern. One by one, the filaments of possession were being broken—that sense which in its grossest terms is really a sort of fatuous pride. Say what we will, most of us feel that we deserve praise and tribute for having selected so attractive a wife, for having begotten such charming children. Having no longer any more of a proprietary interest in Viola than I had in the wild flowers, or the sea, or sky, I got a fresh eye on her. I could not help admiring her, and I could not help admiring her for herself alone. Having no longer any taint of possession, it was impossible for me to impose my will on her, so I adopted unconsciously the courtesy one shows to some one else's wife.

'Well, Viola,' I would say, 'do you want to come home to-night? You don't *have* to.'

She would look up and listen, cock her ears, consider the matter. Sometimes she would decide to stay with Lysander, and sometimes, strangely enough, she would decide to go home with me. If she came, she came happily, because she was exercising the prerogative of an independent creature. Her sense of sin or shame left her; and somehow we were all gainers, Lysander, Viola, and myself. He no longer snapped his fingers or made little sucking noises. These had been psychical reactions from my jealous emanations when we were struggling for Viola's favor; but we were now united in doing what we could to make her happy; and our friendship, which had suffered previously, in this new office became confirmed. What expansive talks we had about her! How he rushed over to tell me the latest example of her wisdom or affection; and when one expects nothing from a dog, it is rather pleasant to feel suddenly, while struggling with a sentence, a damp delightful nose inside your hand.

Sometimes I fancy that Viola, in forming her friendship for Lysander, had a prevision; for the time came when we had to leave her, and in whose hands could it be better to leave her than Lysander's and his wife's?

Most dog stories end with the death of the dog, but I can assure the reader that Viola is still very much alive. Not agile any longer, she has become a

privileged parlor guest, for the stairs are too much for her. Sometimes she even finds it impossible to bury a bone, and then she goes through the pantomime of burying it. She knows that we know that she has not really done it. Her assumption of achievement is ludicrous. Who says dogs have not a sense of humor?

She is beautiful as old ladies are beautiful. If she wore a lace stomacher, she would make a magnificent Rembrandt—rich browns, tawny gold, and, in the heart of the picture, the spirit of her personality as mellow and pervasive as a flame.

I don't see Viola often nowadays, but what I gained by renouncing a purely personal interest in her has extended itself somehow beyond what we know as the realm of time and space. This sounds rather esoteric, but what I mean is that I am very happy whenever I think of her, whether I am with her or not. I feel very near her though we are separated by a hundred miles; and I should not be surprised if, in the muffled 'Woof! Woof!' of her dreams, she often lives again what I happen to be thinking of at the moment—wonderful runs with Teddy, the cocker spaniel, or the homeric combat with the woodchuck beside Simon Brook.

As I sit thinking of Viola, there happens to come into my mind, by one of those odd associations that have so little logic in them, an apparently trivial incident that took place a day or so ago. A couple of little girls stopped me on Arlington Street, Boston, and asked the way to Marlboro Street. It chanced that I was going to Marlboro Street myself, and I offered to conduct them there, but they were walking in the leisurely way of children, taking in everything on the way, and I soon outstripped them. At the corner of Marlboro Street, however, I turned and waved to them to indicate that this was the street they wanted, and they waved back to show that they understood.

That was apparently the end of the incident; but two or three blocks up Marlboro Street, something impelled me to turn. The children had found the street, they were following safely, they were evidently watching me; for

as soon as I turned, they waved again. As I went up the steps of the house where I had an appointment, I looked back for the third time. The children, now become almost fairy-like figures, were still watching me. Up went their hands and up went mine, and across the long length of city street, we waved in greeting and farewell.

I do not know why the incident should have seemed to contain an element of real beauty. I was reminded of George E. Woodberry's poem in which a somewhat similar incident is celebrated. A boy, you remember, while playing, ran heedlessly into the poet, and the poem ends,—

It was only the clinging touch
Of a child in a city street;
It hath made the whole day sweet.

What struck me even more than the beauty of my adventure was the quality of permanence that it seemed to wear. In my under-consciousness, there was something immortal about it. Can it be possible that our casual relations, where love is,—our relations with children, or with strangers whom we shall never see again, or with the lower animals whose span of life is necessarily very limited,—can it be possible that these relations are less ephemeral than we think? Would it be too much to hope that the relation between Viola and myself is a small but permanent addition to the store of worth-while things?

Marevna (Marie Vorobieff)-- Expressionism

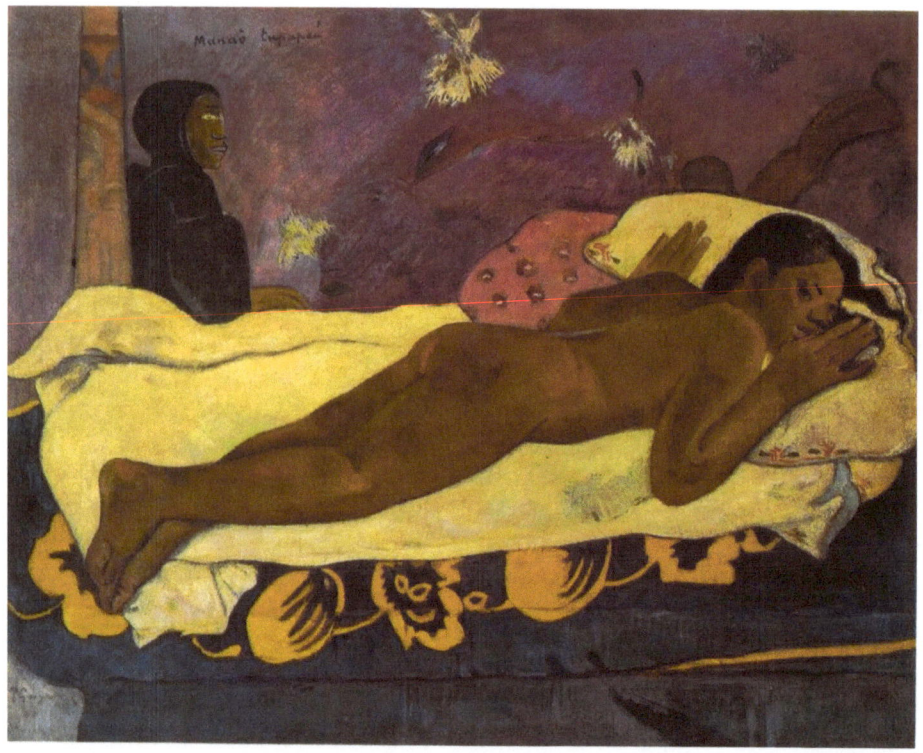

Spirit of the Dead Watching-- Paul Gauguin—1892--Post-Impressionism

Dead Love

By Algernon Charles Swinburne

ABOUT the time of the great troubles in France, that fell out between the parties of Armagnac and of Burgundy, there was slain in a fight in Paris a follower of the Duke John, who was a good knight called Messire Jacques d'Aspremont. This Jacques was a very fair and strong

man, hardy of his hands, and before he was slain he did many things wonderful and of great courage, and forty of the folk of the other party he slew, and many of these were great captains, of whom the chief and the worthiest was Messire Olivier de Bois-Percé; but at last he was shot in the neck with an arrow, so that between the nape and the apple the flesh was cleanly cloven in twain. And when he was dead his men drew forth his body of the fierce battle, and covered it with a fair woven cloak. Then the people of Armagnac, taking good heart because of his death, fell the more heavily upon his followers, and slew very many of them. And a certain soldier, named Amaury de Jacqueville, whom they called Courtebarbe, did best of all that party; for, crying out with great noise, "Sus, sus!" he brought up the men after him, and threw them forward into the hot part of the 190fighting, where there was a sharp clamour; and this Amaury, laughing and crying out as a man that took a great delight in such matters of war, made of himself more noise with smiting and with shouting than any ten, and they of Burgundy were astonished and beaten down. And when he was weary, and his men had got the upper hand of those of Burgundy, he left off slaying, and beheld where Messire d'Aspremont as covered up with his cloak; and he lay just across the door of Messire Olivier, whom the said Jacques had slain, who was also a cousin of Amaury's. Then said Amaury:

"Take up now the body of this dead fellow, and carry it into the house; for my cousin Madame Yolande shall have great delight to behold the face of the fellow dead by whom her husband has got his end, and it shall make the tiding sweeter to her."

So they took up this dead knight Messire Jacques, and carried him into a fair chamber lighted with broad windows, and herein sat the wife of Olivier, who was called Yolande de Craon, and she was akin far off to Pierre de Craon, who would have slain the Constable. And Amaury said to her:

"Fair and dear cousin, and my good lady, we give you for your husband slain the body of him that slew my cousin; make the best cheer that you may, and comfort yourself that he has found a good death and a good friend to do justice on his slayer; for this man was a good knight, and I that have revenged him account myself none of the worst."

And with this Amaury and his people took leave of her. Then Yolande, being left alone, began at first to weep grievously, and so much that she was heavy and weary; and afterward she looked upon the face of Jacques d'Aspremont, and held one of his hands with hers, and said:

"Ah, false thief and coward! it is great pity thou wert not hung on a gallows, who hast slain by treachery the most noble knight of the world, and to me the most loving and faithfulest man alive, and that never did any discourtesy to any man, and was the most single and pure lover that ever a married lady had to be her knight, and never said any word to me but sweet words. Ah, false coward! there was never such a knight of thy kin."

Then, considering his face earnestly, she saw that it was a fair face enough, and by seeming the face of a good knight; and she repented of her bitter words, saying with herself:

"Certainly this one, too, was a good man and valiant," and was sorry for his death.

And she pulled out the arrow-head that was broken, and closed up the wound of his neck with ointments. And then beholding his dead open eyes, she fell into a torrent of weeping, so that her tears fell all over his face and throat. And all the time of this bitter sorrow she thought how goodly a man this Jacques must have been in his life, who being dead had such power upon her pity. And for compassion of his great beauty she wept so exceedingly and long that she fell down upon

his body in a swoon, embracing him, and so lay the space of two hours with her face against his; and being awaked she had no other desire but only to behold him again, and so all that day neither ate nor slept at all, but for the most part lay and wept. And afterward, out of her love, she caused the body of this knight to be preserved with spice, and made him a golden coffin open at the top, and clothed him with the fairest clothes she could get, and had this coffin always by her bed in her chamber. And when this was done she sat down over against him and held his erect arms about her neck, weeping, and she said:

"Ah, Jacques! although alive I was not worthy, so that I never saw the beauty and goodness of your living body with my sorrowful eyes, yet now being dead, I thank God that I have this grace to behold you. Alas, Jacques! you have no sight now to discern what things are beautiful, therefore you may now love me as well as another, for with dead men there is no difference of women. But, truly, although I were the fairest of all Christian women that now is, I were in nowise worthy to love you; nevertheless, have compassion upon me that for your sake have forgotten the most noble husband of the world."

And this Yolande, that made such complaining of love to a dead man, was one of the fairest ladies of all that time, and of great reputation; and there were many good men that loved her greatly, and would fain have had some favour at her hands; of whom she made no account, saying always, that her dead lover was better than many lovers living. Then certain people said that she was bewitched; and one of these was Amaury. And they would have taken the body to burn it, that the charm might be brought to an end; for they said that a demon had entered in and taken it in possession; which she hearing fell into extreme rage, and said that if her lover were alive, there was not so good a knight among them, that he should undertake the charge of that saying; at which speech of hers there was great laughter. And upon a night there came into her house Amaury and certain others, that were minded to see this matter for themselves. And no man kept the doors;

for all her people had gone away, saving only a damsel that remained with her; and the doors stood open, as in a house where there is no man. And they stood in the doorway of her chamber, and heard her say this that ensues: —

"O most fair and perfect knight, the best that ever was in any time of battle, or in any company of ladies, and the most courteous man, have pity upon me, most sorrowful woman and handmaid. For in your life you had some other lady to love you, and were to her a most true and good lover; but now you have none other but me only, and I am not worthy that you should so much as kiss me on my sad lips, wherein is all this lamentation. And though your own lady were the fairer and the more worthy, yet consider, for God's pity and mine, how she has forgotten the love of your body and the kindness of your espousals, and lives easily with some other man, and is wedded to him with all honour; but I have neither ease nor honour, and yet I am your true maiden and servant."

And then she embraced and kissed him many times. And Amaury was very wroth, but he refrained himself: and his friends were troubled and full of wonder. Then they beheld how she held his body between her arms, and kissed him in the neck with all her strength; and after a certain time it seemed to them that the body of Jacques moved and sat up; and she was no whit amazed, but rose up with him, embracing him. And Jacques said to her:

"I beseech you, now that you would make a covenant with me, to love me always."

And she bowed her head suddenly, and said nothing.

Then said Jacques:

"Seeing you have done so much for love of me, we twain shall never go in sunder: and for this reason has God given back to me the life of my mortal body."

And after this they had the greatest joy together, and the most perfect solace that may be imagined: and she sat and beheld him, and many times fell into a little quick laughter for her great pleasure and delight.

Then came Amaury suddenly into the chamber, and caught his sword into his hand, and said to her:

"Ah, wicked leman, now at length is come the end of thy horrible love and of thy life at once;" and smote her through the two sides with his sword, so that she fell down, and with a great sigh full unwillingly delivered up her spirit, which was no sooner fled out of her perishing body, but immediately the soul departed also out of the body of her lover, and he became as one that had been all those days dead. And the next day the people caused their two bodies to be burned openly in the place where witches were used 197to be burned: and it is reported by some that an evil spirit was seen to come out of the mouth of Jacques d'Aspremont, with a most pitiful cry, like the cry of a hurt beast. By which thing all men knew that the soul of this woman, for the folly of her sinful and most strange affection, was thus evidently given over to the delusion of the evil one and the pains of condemnation.

Cunnilingus, or oral sex performed on a woman--Francesco Hayez--Romanticism

Paul-Emile Bécat

From *I Ragionamenti di Pietro l'Aretino*

www.ingramcontent.com/pod-product-compliance
Lightning Source LLC
Chambersburg PA
CBHW051027180526
45172CB00002B/493